A Kid's Guide to Drawing™

How to Draw
Passover Symbols

Christine Webster

The Rosen Publishing Group's
PowerKids Press™
New York

To my sister, Teresa

Published in 2005 by The Rosen Publishing Group, Inc.
29 East 21st Street, New York, NY 10010

First Edition

Editor: Orli Zuravicky
Book Design: Kim Sonsky
Layout Design: Mike Donnellan

Illustration Credits: Jamie Grecco
Photo Credits: pp.6, 16 © Royalty-Free/CORBIS; p.8 © Eric and David Hosking/CORBIS; p.10 © Inga Spence/Index Stock Imagery, Inc.; p.12 © ASAP Ltd./Index Stock Imagery, Inc.; p.14 © Historical Picture Archive/CORBIS; p.18 © David Wasserman/Index Stock Imagery, Inc.; p.20 © Bud Freund/Index Stock Imagery, Inc.

Library of Congress Cataloging-in-Publication Data

Webster, Christine.
How to draw Passover symbols / Christine Webster.
 v. cm. — (A kid's guide to drawing)
Includes bibliographical references and index.
Contents: Passover symbols — Slaves in Egypt — The ten plagues — The Lamb — Matzah — The parting of the Red Sea — Chametz — The Seder plate — Elijah's Kiddish cup — Glossary — Web sites.
ISBN 1-4042-2729-6 (lib. bdg.)
1. Passover in art—Juvenile literature. 2. Drawing—Technique—Juvenile literature. [1. Passover in art. 2. Drawing—Technique.] I. Title. II. Series.
NC825.P37 W43 2005
743'.8896—dc22

 2003019587

Manufactured in the United States of America

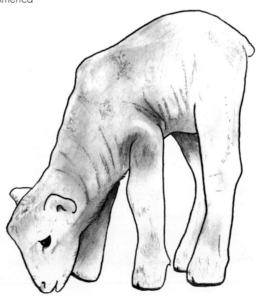

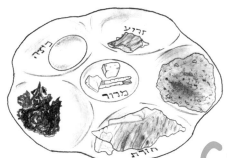

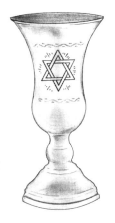

CONTENTS

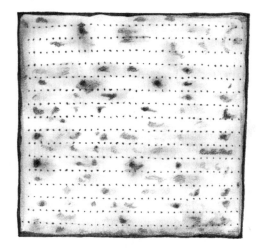

Passover Symbols

Passover is one of the most important holidays on the Jewish calendar. The Jewish **religion**, or Judaism, is based on the teachings of the **Torah**. Passover takes place every spring and lasts for eight days.

The events of the Passover story took place about 3,000 years ago. A great food shortage spread across Canaan, which was the land of the Israelites, or Jewish people. They were forced to leave their homeland and move to Egypt, where there was food. After the Israelites had been living in Egypt happily for some time, a new ruler came into power. The Israelites were no longer welcomed there. The new **pharaoh**, or ruler of Egypt, forced them into **slavery**. One day a young Israelite boy named Moses heard the voice of God commanding him to lead his people to freedom. Although Moses begged for their freedom, Pharaoh would not free the Israelites. Finally God's powerful deeds forced Pharaoh to set the Israelites free.

The Passover holiday **celebrates** the end of the Israelites' **enslavement** and the beginning of a new life

for the Jewish people. On this holiday, Jews remember the story of their **ancestors'** struggle for freedom from the Egyptians and throughout history. Passover is celebrated at home with a special meal called a seder. "Seder" means "order" in **Hebrew**. The seder helps people to remember the order of events in the Passover story. The **traditions** and songs that tell the story of Passover are read from a book called a Haggadah. The Passover celebration includes blessings, prayers, songs, and special foods.

In this book, you will learn all about Passover. You will also learn how to draw some of Passover's **symbols**. Have fun and be creative. Follow the directions and the steps drawn in red to create your own Passover symbols. Be sure to check out the drawing terms and shapes on page 22.

The supplies you will need to draw each Passover symbol are:
- A sketch pad
- A number 2 pencil
- A pencil sharpener
- An eraser

Slavery in Egypt

The Israelite population increased quickly. Pharaoh Ramses II, leader of Egypt, forced the Israelites into slavery to control their power. The Israelites worked long hours and lugged large stones in the hot sun to build Egyptian **pyramids**. Egyptians often beat the Israelites. Pharaoh also ordered that every first newborn Israelite son be killed to stop the Jewish population from growing. One Israelite woman saved her firstborn son from death by placing him in a basket, which she sent floating down the Nile River. This child, Moses, grew to be a great leader of the Jewish people. He led them out of slavery in Egypt to their home in Israel. During Passover, Jews remember their ancestors' suffering by retelling the story at the seder and eating a food called *charoset*. It **symbolizes** the **mortar** used to build the pyramids.

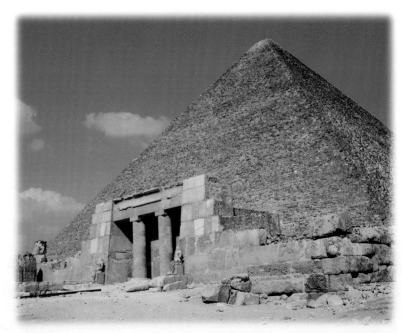

1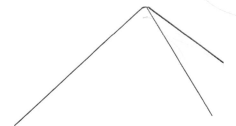

Draw three angled lines so that they connect at the top. This will be the basic shape of the pyramid.

2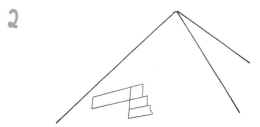

Add four rectangular shapes. They will be the stones at the pyramid's entrance.

3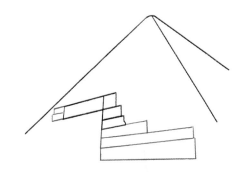

Draw lines to make five more rectangular shapes.

4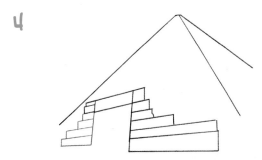

Add lines to make more rectangular shapes to finish the entrance.

5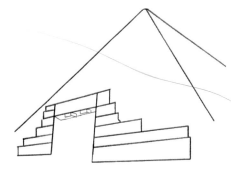

At the top of the entryway, draw four small rectangular shapes. Underneath those shapes draw two lines as shown.

6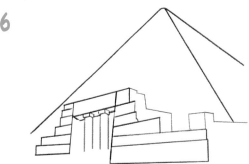

Add four straight vertical lines for columns. Draw lines around the right side of the pyramid.

7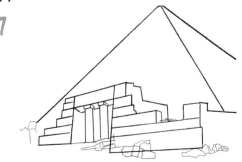

Add stones around the pyramid and extra lines as shown to complete the pyramid.

8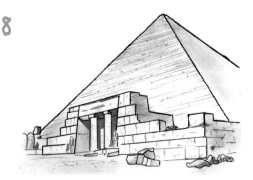

You can draw lines on the pyramid to show the separate stones used to build it. Finish by shading. Great job!

7

The 10 Plagues

God cast 10 **plagues** on the Egyptian people to get Pharaoh to free the Israelites. First God turned the Nile River to blood to warn Egyptians of his power. Pharaoh did not free the Israelites. God **infested** Egypt with millions of frogs. He turned the sand of Egyptian deserts to **lice** and killed Egyptian cattle with illnesses. He sent masses of flies to attack the Egyptian people. He gave Egyptians **boils**, sent snowstorms and **locusts**, and turned light to darkness. The tenth plague, which was the death of every firstborn Egyptian son, finally forced Pharaoh to set the Israelites free.

As the name of each plague is read aloud at the seder, everyone at the table dips one finger into a glass of wine and places a drop of wine onto his or her plate. These 10 drops of wine symbolize the compassion, or understanding, that Jews have for those who suffered from these plagues.

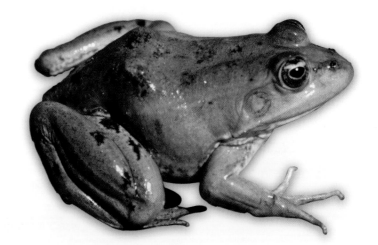

1

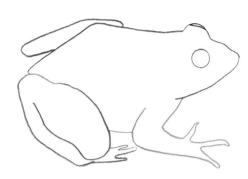

Start by drawing a circle. This will be the frog's right eye.

2

Draw the shape of the body and the head of the frog using curved lines. Notice the bump on top of the frog's head. That will be the frog's left eye.

3

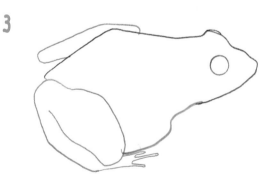

Use curved lines to draw the frog's hind legs and right foot. Notice the shape of the frog's three toes.

4

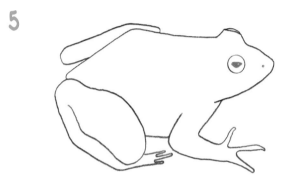

Draw the front arm and hand, including the three fingers. Connect the front arm to the back leg with a curved line for the middle section of the frog's body. Notice that the front arm also connects to the frog's head.

5

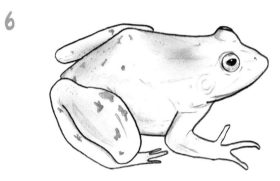

Draw in the frog's eye and nose as shown.

6

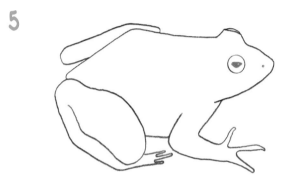

Add shading as shown in the picture and you are all done. Your frog looks great!

The Lamb

For the tenth plague, God told Moses that he would send the angel of death to kill the firstborn son in every Egyptian household. To save the Israelite children, Moses followed God's directions. Moses told each Jewish family to kill a lamb and smear its blood on the doorpost of the house. Because the Jews marked their doors, the angel of death would know to "pass over" the Jewish homes and to save the Jewish children. This is where the name Passover came from.

After this plague, Pharaoh finally let the Jewish people leave Egypt. He realized that Moses's God was more powerful even than a pharaoh. A dry lamb bone is placed on the seder table as a reminder of the lambs that were killed thousands of years ago in order to save the Israelites from the tenth plague.

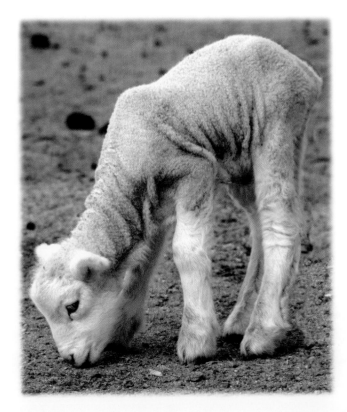

1

Draw two circles for the body of the lamb. Notice their sizes and how they overlap on one side.

2

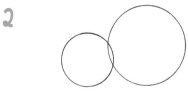

Add two more circles for the head. Again, one circle is bigger than the other. The circles overlap.

3

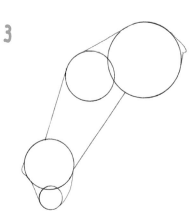

Using straight and curved lines, draw the shape of the head, the body, and the neck by connecting the circles. Be sure to draw the lamb's tail as shown.

4

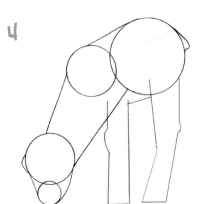

Draw straight lines for the two legs, as shown. Use curved lines for the knees.

5

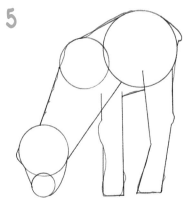

Shape the lamb, using the circles and lines as your guide.

6

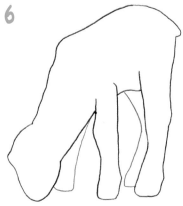

Erase any extra lines. Draw the other two legs using curved lines.

7

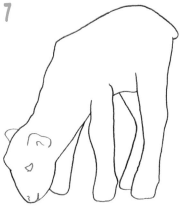

Draw the lamb's eye, mouth, nose, and ears as shown.

8

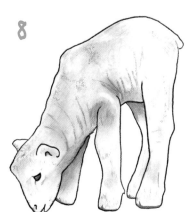

Add shading to your drawing and finish as shown. Your lamb is all done!

Matzah

Matzah is a special type of **unleavened**, or unrisen, flat bread made only from water and flour. When Pharaoh let the Israelites go, they left quickly. They feared that he would change his mind. In a rush, they gathered whatever they could carry and whatever food they were making. With no time to wait for the bread to rise, they **grabbed** the unbaked bread and left Egypt. They carried heavy bags on their backs. It is believed that the sun baked the dough during the long journey in the desert. The bread came out flat.

Jews eat matzah during the week of Passover as a reminder of their ancestors' struggle to escape from Egypt. The matzah-making method, from mixing to baking, can last only for 18 minutes, or the bread will start to rise. A piece of matzah called the *afikoman* is hidden during the seder. The person who finds it gets a present.

1

Draw a large square shape for the outline of the matzah.

2

Trace over the edges to make the matzah appear more natural. Erase guidelines.

3

Draw eight horizontal lines across the matzah. These lines will be used as guides for the holes in the matzah.

4

Next draw eight more lines as shown.

5

Draw the holes by making small dots on the horizontal lines. Erase the lines between the dots.

6

Add shading to finish your matzah as shown. Great job! Your matzah is all ready for the Passover table.

The Parting of the Red Sea

For 40 days and nights, the Israelites traveled across dusty deserts. When they reached the shores of the Red Sea they heard Pharaoh's army approaching quickly. Pharaoh had changed his mind. God told Moses to strike his staff, or stick, on the waters of the Red Sea. Moses obeyed. The sea **split** in half and formed a pathway for the Israelites to cross. With the the Egyptian army close behind them, the Israelites began to cross the sea. Once they were safely across, God told Moses to strike the waters again. The two sides of the sea came together to cover the land. The entire Egyptian army drowned. At a seder, matzah is broken into two pieces to symbolize the parting of the Red Sea long ago.

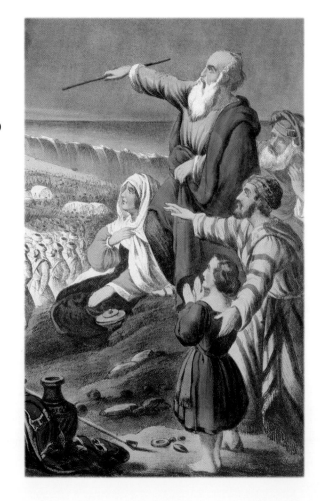

1 Draw three ovals as shown in the picture. The ovals will be people's heads.

5 Draw the two men's robes and the girl's dress using your straight lines as guides. Notice that Moses is also wearing a cloak.

2 Using straight lines, draw the shape of Moses's body and arm. Notice how his left side connects to the oval on the right.

6 Erase extra lines. Using the ovals as guides, draw the faces. Draw a line on Moses's sleeve, beards for the men, and hair for everyone. Draw the hat on the second man's head.

3 Using straight lines, add the shape of the man next to Moses.

7 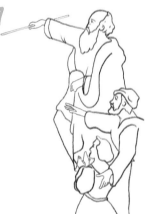 Erase the ovals and add the stick in Moses's hand. Finish the shapes of the hands and the fingers as shown. Erase all extra lines.

4 Draw the shape of the little girl's dress, arm, and hands as shown in the picture. Next add the basic shape of the hands on the two other men.

8 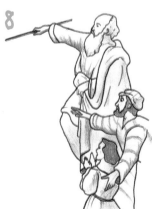 Add shading as shown in the picture and you are done!

15

Chametz

Before Passover begins, Jews clean their homes of *chametz*. Chametz is a Hebrew word. It stands for all food and drink made from grains such as wheat and barley combined with **yeast**. These foods are not eaten during Passover because they have risen during baking. Before Passover Jews clean their homes of bagels, waffles, cakes, and even cookies! The **rabbi** helps them sell or give their chametz to the needy so that the food is not wasted. Instead Jews buy special foods that are free of chametz, such as matzah.

Jews use this special time of cleansing to clear their hearts and minds as well. They clear their minds of bad thoughts about other people and remind themselves that all people are equal.

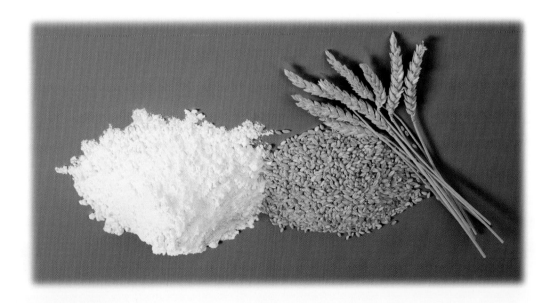

1

Use wavy lines to shape the rounded pile of the first grain.

5

Add two more heads of wheat as shown.

2

Use wavy lines to add the shape of the second pile of grain.

6

Add the stems of the wheat using straight lines as shown.

3

Add the first head of wheat using very small triangular leaves.

7

Draw the seeds of the second grain using tiny ovals as shown.

4

Next add four more heads of wheat.

8

Finish drawing the seeds and add shading to finish your chametz and you are all done!

The Seder Plate

The seder plate, or *k'arah*, is a round plate with six items that symbolize the story of Passover. *Karpas*, a vegetable such as parsley or celery, represents springtime and new life. Before it is eaten, it is dipped into a bowl of salt water, which symbolizes the Israelites' tears. *Zero'a*, a dry bone, symbolizes the lamb that was **sacrificed**. Made from apples, nuts, dates, wine, and cinnamon, the charoset represents the mortar that the enslaved Jews used to build the pyramids. Bitter herbs, known as *maror*, remind the Jews how bitter the Egyptians made the Israelites' lives. *Chazeret*, a bitter vegetable, reminds Jews of their enslavement. A hard-boiled egg, called a *beitzah*, stands for springtime and for the new life that began when the Jews' slavery ended.

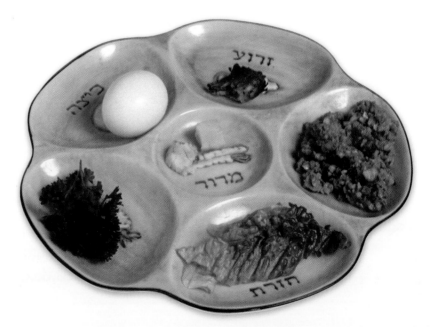

1

Using curved lines, draw the shape of the platter.

2

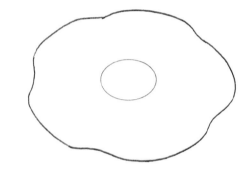

Add an oval in the center of the shape.

3

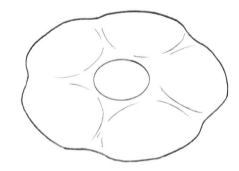

Draw some light curves to create the shapes of the dips in the platter. Later you will shade them in.

4

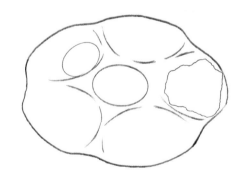

Draw the egg as shown in the picture. Then draw the shape of the charoset in the space on the right.

5

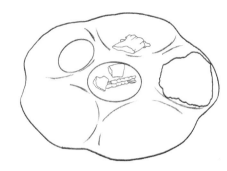

Add the dry bone in the top space. Draw the shape of the bitter herbs in the center space, along with the picture in the center of the plate.

6

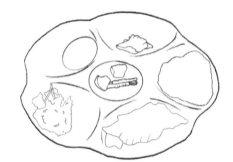

Finish by drawing the parsley and the lettuce in their correct spaces as shown.

7

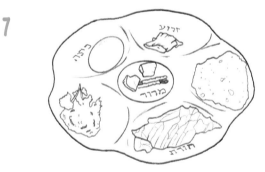

Add the Hebrew words for the foods. Add some lines and circles to the foods.

8

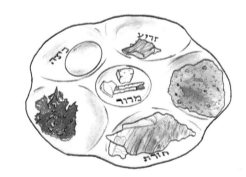

Next add shading. Your seder plate looks great!

Elijah's Cup

It is a tradition for Jews to drink wine at the Passover seder. In Jewish law, it is unclear whether each person should drink four or five cups of wine. Today Jews drink four cups of wine and pour a fifth cup of wine, which they do not drink. The fifth cup is for Elijah the **prophet**. Elijah was a great **miracle** worker who lived long ago. It is said that he never died but was taken to heaven. Jews believe that one day Elijah will return to answer all unanswered questions and announce the coming of the **Messiah**. Jews welcome Elijah by leaving their front doors open for him and singing a special song. They believe that if his wine ever disappears, Elijah has returned to answer the wine question and to announce the Messiah, who will fix all the problems in the world. Welcoming Elijah also reminds Jews to be giving to people who are less **fortunate** than they are.

1 Draw two circles as shown in the picture. Notice that the top circle is bigger than the bottom circle.

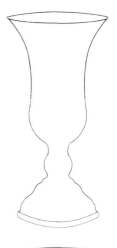

5 Erase any extra lines.

2 Draw a thin oval for the opening of the cup.

6 Add two triangles, as shown, in the center to begin the Jewish star, or Star of David. Notice that one triangle is drawn inside the other.

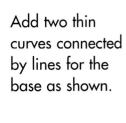

3 Add two thin curves connected by lines for the base as shown.

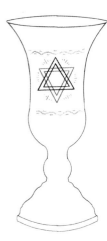

7 Add two more triangles, as shown, overlapping the first two triangles, to finish the Star of David. Add extra shapes as shown in the picture.

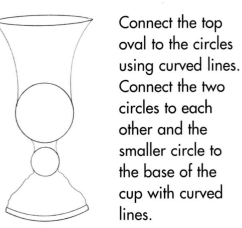

4 Connect the top oval to the circles using curved lines. Connect the two circles to each other and the smaller circle to the base of the cup with curved lines.

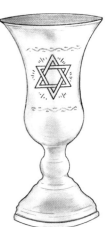

8 Add shading and you are done! Elijah's cup is all ready for the seder. Great job!

21

Drawing Terms

Here are some words and shapes you will need to draw the Passover symbols:

○ circle

∿ curved line

— horizontal line

⬭ oval

▭ rectangle

◣ shading

□ square

△ triangle

| vertical line

∿ wavy line

Glossary

ancestors (AN-ses-terz) Relatives who lived long ago.

boils (BOYLZ) A sickness of the skin that causes big sores all over the body.

celebrates (SEH-luh-brayts) Observes an important occasion with special activities.

enslavement (en-SLAYV-mint) The condition of being a slave.

fortunate (FORCH-net) Lucky.

grabbed (GRABD) Took with force or speed.

Hebrew (HEE-broo) Language spoken by Jewish people.

infested (in-FEST-ed) Filled a place, usually with unpleasant things.

lice (LYS) Small bugs that live on people.

locusts (LOH-kusts) Packs of grasshoppers that overrun a place.

Messiah (meh-SY-uh) The expected king of the Jews.

miracle (MEER-uh-kul) A wonderful or an unusual event said to have been done by God.

mortar (MOR-tur) A mixture of lime, cement, sand, and water for holding bricks or stones together.

pharaoh (FER-oh) An ancient Egyptian ruler.

plagues (PLAYGZ) Very bad illnesses, curses, or hardships.

prophet (PRAH-fet) A leader of faith who speaks as the voice of God.

pyramids (PEER-uh-midz) Large, stone structures with square bottoms and triangular sides that meet at a point on top.

rabbi (RA-by) A leader of the Jewish faith.

religion (ree-LIH-jen) A belief in and a way of worshiping a god or gods.

sacrificed (SA-krih-fysd) Gave up for a belief.

slavery (SLAY-vuh-ree) The system of one person "owning" another.

split (SPLIT) To separate or break in half.

symbolizes (SIM-buh-lyz-ez) Stands for something else.

symbols (SIM-bulz) Objects or pictures that stand for something else.

Torah (TOR-eh) The first five books of Jewish law.

traditions (truh-DIH-shunz) Ways of doing things that have been passed down over time.

unleavened (un-LEH-vend) Unrisen.

yeast (YEEST) Something that is used in baking to make dough rise.

Index

Web Sites

Due to the changing nature of Internet links, PowerKids Press has developed an online list of Web sites related to the subject of this book. This site is updated regularly. Please use this link to access the list:
www.powerkidslinks.com/kgd/passym/